M000274245

Every Day Devotions
for
Everyday People

Every Day Devotions
for
Everyday People

COLOR YOUR LIFE
WITH CHRIST

Gail Huber

Charleston, SC
www.PalmettoPublishing.com

Every Day Devotions for Everyday People

Copyright © 2021 by Gail Huber

All rights reserved.

No portion of this book may be reproduced, stored in a retrieval system, or transmitted in any form by any means—electronic, mechanical, photocopy, recording, or other—except for brief quotations in printed reviews, without prior permission of the author.

First Edition

Hardcover ISBN: 978-1-63837-821-1
Paperback ISBN: 978-1-63837-822-8

This book is lovingly dedicated to my husband, Vern, who has been my encourager for almost 48 years.
You've believed in me and cheered me on to do this devotional to share with others.
I would also like to thank my editor and friend, Mary Evelyn Poole, for all your hard work on my first project.
You're awesome! And most of all, I give glory to God for the inspirations to paint and to write.
I thank Him for all my talents, and know that I would be nothing without Him.

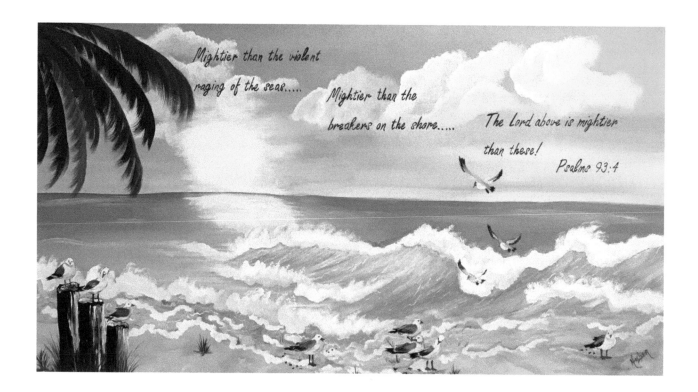

Mightier than the violent raging of the seas.....

Mightier than the breakers on the shore.....

The Lord above is mightier than these!

Psalms 93:4

Today's Verse:

The Son radiates God's own glory and expresses the very character of God, and He sustains everything by the mighty power of His command. When He had cleansed us from our sins, He sat down in the place of Honor at the right hand of the majestic God in Heaven.

HEBREWS 1:3 (NIV)

I know of fewer places on this earth that express the very character of God than a day at the oceanside. Some people find peace and God expressing Himself in the mountains; in the nature of the woods; or by a stream of water. However for me, God expresses Himself on the beach. God is so busy all the time. I imagine Him trying to juggle so many prayer requests at the same time; listening to His children and guiding and directing each of us when we are lost. He's so busy!

That's the way the beach is to me....busy! The ebb and flow of the water never stops, and yet God commands it where to stop and how far to go. There are living creatures that we can't even see in and around the ocean. Yet, God sees each one and protects each one. He orders their path by His great command.

At the beach I feel at peace, even with all its busyness. I don't know about you, but today I need peace in my life. I need to stop my busyness and ask God to guide and direct my path, like He does all the elements at the beach. I need HIS peace in my life. Will you pause and take a moment to pray with me? You fill in your blanks as you pray.

Father, today I thank You for_____ (be specific). Will You take my life and put things in order, and help me find peace? Help me follow Your lead; Your calling; Your prescription to replace the chaos in my life with order and peace. Please cleanse me from my sins, and know that I love You and want Your will in my life. When I am in Your will, I will live in peace. In Jesus' name!

Today's Verse:

You visit the earth and cause it to overflow; You greatly enrich it; The river of God is full of water; You provide their grain, For so You have prepared it.

PSALM 65:9 (NKJV)

I grew up on a farm in Illinois. As a child, I never understood the natural order of things that had to take place in order for us to have food on our table from the garden and fields, and food from the animals. My dad and brothers would get up early each morning to milk the cows. Later my mom would pasteurize the milk and skim the cream from the top of the milk. With that, my mom would make so many wonderful things with these blessings. We would have fresh cream on top of our fresh strawberries picked from our own garden. We would have fresh butter for our homemade bread, and the list goes on.

In the fall, my dad and other relatives would butcher the cows and pigs we had raised on our farm so we would have protein for the winter months. There were 9 children in my family, and we needed lots of meat! Even the blessing of family – I just never saw it as a blessing when I was a child. I never really thought about what had to take place for all this food to be produced. As a kid I thought you just went to the market and bought whatever you needed. I'm sure many youngsters today think the same thing.

I failed to see the blessings in having family, in the rain, the sun, the fertilizer, the raising of the animals, and the gardens we worked in each year. To us kids, it was just a lot of work. But as an adult, I understand now that all of this was a natural progression of God's blessings for our provisions.

Do you have blessings in your life that you take for granted? What are some things you can thank God for today?

Father, you have blessed me with so many things I have taken for granted. I want to thank You for_____ (be specific). I praise You for these blessings. Guide me to see the bountiful blessings You have given me and don't let me take them for granted. Help me want to share those blessings with others, as you have blessed me. In Jesus' name!

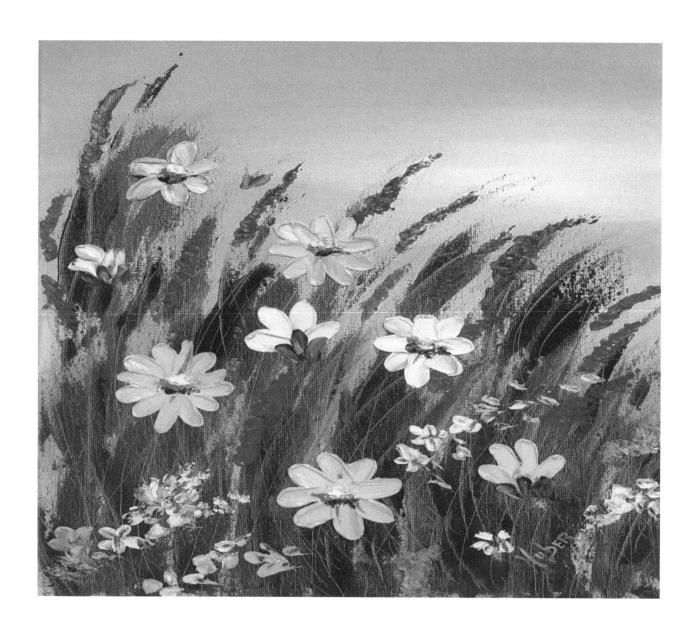

Today's Verse:

Make a careful exploration of who you are and the work you have been given, and then sink yourself into that. Don't be impressed with yourself. Don't compare yourself with others. Each of you must take responsibility for doing the creative best you can with your own life.

GALATIANS 6:4-5 (MSG)

*D*o you struggle with self-esteem? Or am I the only one? For so many times in my life the cause for my low self-esteem is because I have tried to compare my work with someone else's work. This scripture clearly says we shouldn't do that. We are to make careful exploration of who "we" are and the work "we" have been given, and then sink ourselves into that. This scripture clearly tells us not to compare ourselves with others. Each one of us is responsible for what God has given us to do.

As I was painting this flower picture I never thought about how much prettier one flower would be from another, or how many petals one flower would have and the other flower not have as many petals. No! Each flower was painted individually for its own beauty. In life, one flower doesn't say to the other, "Today I think I'll outshine you," or, "Today I think I'll grow more petals than you." God created each flower with its own beauty for its own function.

So it is with us. God created each one of us to function in a different way. We each have our own job to do on this earth, and God has given us the tools to do His will in this life. Stop trying to compare yourself with your neighbor, your co-worker, your friends, or your siblings. You are uniquely made to do HIS will and to do "the creative best you can with your own life."

Dear God, today I ask that you help me stop comparing myself with_____. Help me to do my creative best with what You have given me. Help me strive to please You and not others. I know if I please You then I will be doing the best I can with what I have. In Jesus' name!

Today's Verse:

Let us hold fast the confession of our hope without wavering, for He who promised is faithful.
And let us consider one another in order to stir up love and good works.

Hebrews 10: 23-24 (NKJV)

You are so essential! God has a purpose for each one of us. You may have a gift or gifts that you need to share with your friends, neighbors, and others in your community. Don't try to hide the fact that you have been given special talents. Those gifts were given to share with others.

You may have been given the gift of hospitality. If so, entertain others so you can share Jesus through your hospitality. You may have been given the gift of baking scrumptious delicacies. If so, bake something for your friend in need. You may have been given the gift of listening. Then listen to someone who is hurting and be the extension of God's love and grace. You may have been given the gift of painting. If so, share your art with the world. In so doing, you share what God has given you. You may have been given the gift of wealth. If so, help out a friend that is down on their luck. Don't ever expect anything in return, because then it's a debt to be paid, not a gift.

We've all been given some type of gift. The key to helping our gifts grow is to share them with each other. By doing this, we will spur others on to do "acts of love and good works for others." We can all make this world a better place if we put God in the middle of the talents He has given us. Think of one gift (you may have many) that God has given you and then use it to glorify Him today. By doing this, you will motivate others to do the same without saying a word.

Lord, today help me to use the talent of_____ to help my friend, brother, sister, or someone in my community today. Help me glorify You with what you have given me. In Jesus name!

Today's Verse:

The Lord is my shepherd; I shall not want. He maketh me to lie down in green pastures: he leadeth me beside the still waters. He restoreth my soul: he leadeth me in the paths of righteousness for His name's sake.

PSALM 23:1-3 (KJV)

When I was a child my mom would make sure my younger sister and I went to Vacation Bible School (VBS) at our church every year. One year, our challenge in VBS was to memorize the entire chapter of Psalms 23. I am happy to say that I actually did memorize that chapter. However, I had no idea at the time how that Bible chapter would comfort me in my adult years. There are many power verbs in just the first three verses: Makes; leads; restores. When I think of these verses, I can imagine a quiet lake of water where I can sit in the green grass beside the water and listen to the stillness; it's there that I listen to the voice of God. There He restores or reestablishes my soul. He helps me know that I am His child. He leads me in paths of righteousness. He teaches me honesty and how to live a blameless life.

I have been in situations in my adult years where I have found myself reciting the entire chapter of Psalms 23. It would center my soul. It restored and comforted me. My how God has spoken to me in this chapter! The entire chapter is filled with words that make you realize how powerful God is. If you've never memorized anything from the Bible before, I challenge you to do so. It may not be an entire chapter. It might only be a verse that speaks to you in a moment of need. Whatever it is, memorize His words. You may not always have a Bible handy where you can look up that verse. If you have it memorized, God will call it to your remembrance when you need a Word from God the most.

Father, today I pray that You will help me desire to memorize Your Word. I want to hide it in my heart so I can hear You speak to me, guide me, and restore me. In Jesus' name!

Today's Verse:

*"Come now, let us settle the matter,' says the Lord. 'Though your sins are like scarlet,
they shall be as white as snow; though they are red as crimson, they shall be like wool."*

ISAIAH 1:18 (NIV)

I live in Kentucky where the spring season is so vivid with bright colors. The skies are full of blue, white, and pink hues of color. This particular painting brought to mind the scripture above. Even though the trees and the grass were in full bloom, the snow came one morning and covered the flowers so you could barely see the beautiful colors.

"Though my sins are like scarlet, they shall be as white as snow." Just like the snow covers the colors of spring I am comforted to know that even though I sin, and it happens every day, God's love and His blood cover my sin. God's love for me and for you is as pure as the new fallen snow in this picture. He gives us a fresh start every time we repent of our sins. One day we will be perfect when we see Jesus. That is a promise if we follow Jesus.

There are times when I feel I've messed up so badly God can't forgive me. However, because of Jesus, we can have our sins forgiven if we just ask. I John 1:9 says, "If we confess our sins, He is faithful and just to forgive us our sins and to cleanse us from all unrighteousness." (ESV)

If you feel you've messed up beyond repair, think again. God promises exactly the opposite if we confess and repent.

Father, this has been a hard week. I've done and said things (be specific) that I wish I hadn't. I humbly bring this to You and ask for Your forgiveness. Help me to be stronger when temptations come. Help me to live my life in a way that is pleasing to You. I want to follow You. I want people to see You in me. Please cleanse me from my sins. In Jesus' name!

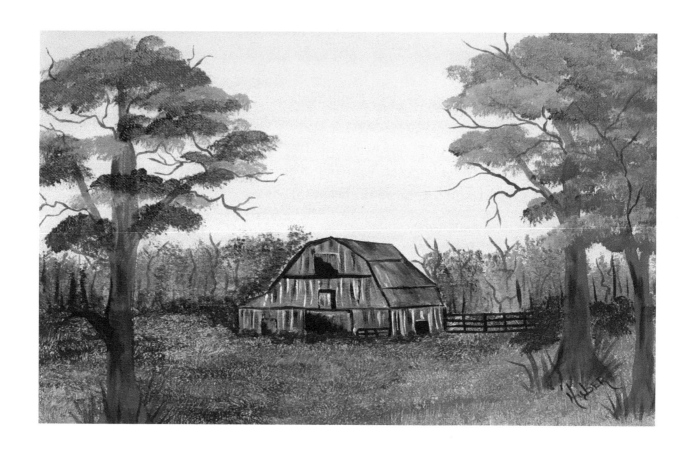

Today's Verse:

Whatever you do, work at it with all your heart, as though
you were working for the Lord and not for people.

COLOSSIANS 3:23 (GNT)

*T*his barn scape reminds me of my childhood. I grew up on a farm in Illinois, along with my mom, dad, and eight other siblings. Life was tough at times on this farm. However, we never worried about whether we would have another meal or not. My dad worked from daylight to dusk plowing the ground for corn and beans, taking care of the cows, pigs, chickens, and the garden. With each of these tasks we knew we would be provided for. My dad and mom were doers. They worked at everything with their whole hearts.

My mom was a Christian all her life, but sadly, my dad was not. So I'm not so sure he was "working for the Lord, and not people." But my mom never gave up praying for him to accept Jesus. My dad usually worked in the fields on Sundays to catch up on the things he didn't get done through the week.

Then one Sunday, my younger sister and I were going to sing at church. We were only about five and seven years old. My mom asked him to come to church to hear us sing. Surprisingly, he came. From that Sunday on he came to church with us every Sunday, and he no longer worked in the fields on Sunday. Then one day, my dad gave his life to Christ and asked Him to be his Lord and Savior. I believe then, he began to work with all his heart as though he were working for the Lord, and not people. Maybe you have someone you need to pray for today.

Father, I want to lift up _____ to You today. I pray that they will hear Your voice, and maybe for the first time, listen to Your voice calling them into the fold. Would You please send someone to speak truth to this person so they could understand Your love for them? May they receive You into their hearts and take You as their Lord and Savior. In Jesus' name!

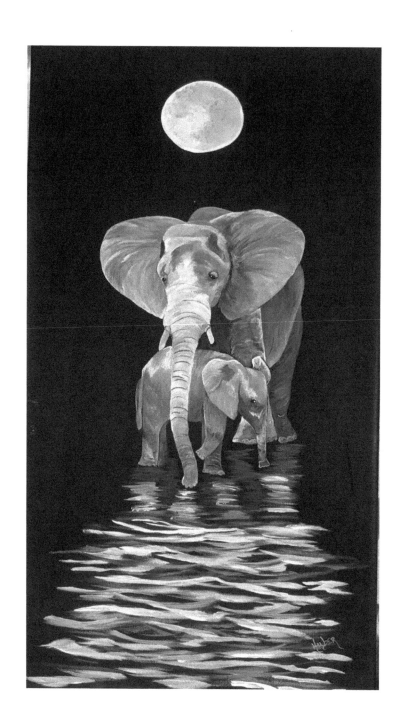

Today's Verse:

"Can a mother forget the baby at her breast and have no compassion on the child she has born? Though she may forget, I will not forget you! See, I have engraved you on the palms of my hands; your walls are ever before me."

Isaiah 49:15-16 (NIV)

*I*n 2001 we had experienced the panic and chaos of the Twin Towers falling in New York. There were so many lives lost in that horrific terrorist attack. Our lives would be forever changed because of this attack.

The year was 2004, and our oldest son was to be shipped to Ar Ramadi in Iraq. He had joined the Army earlier in the summer of 2004, and now the time had come to put what he had learned in training to use to protect our country. But I remember as he was leaving for boot camp, I knew we weren't going to have contact with him for a while. I wanted him to have something to remember while he was away. I started giving him scriptures to write down in the front of his Bible for another type of training. Isaiah 49:15 was one of the scriptures I gave him. I reminded him that even though I would not be with him physically, God would have him engraved in the palms of His hands, and He would ALWAYS be with him, wherever he was.

In this painting, the mother elephant is guarding her young calf . That's the way it is with God. He goes before us and shelters us with His love and we are ever before Him. I knew even though I no longer could protect my son, or see him every day, God would hold him in the palms of His hands. Maybe there is someone you need to pray for today.

Abba, Father, today I lift up _____. I can't be with him/her today, but they are going through things and he/she needs Your help, Your comfort, and Your protection. Please keep him/her safe because You promised not to forget them. Please keep them engraved in the palms of Your hands, and keep him/her ever before You. In Jesus Name!

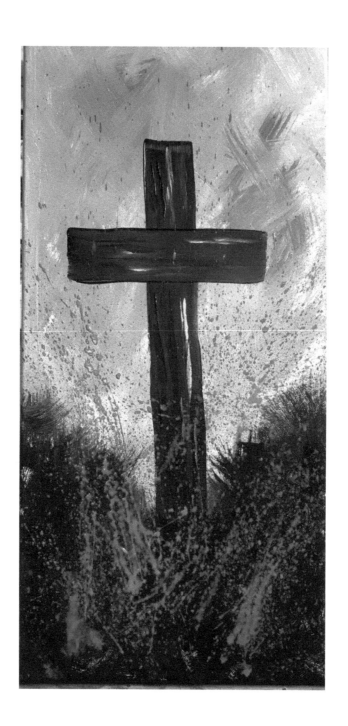

Today's Verse:

For God so loved the world that He gave His one and only Son, that whoever believes in him shall not perish but have eternal life. For God did not send His Son into the world to condemn the world, but to save the world through Him.

JOHN 3:16-17 (NIV)

*W*e have this painting hanging in our home to remind us of the love and grace God has for us. Despite all our sins and all our wickedness God still loved us enough to send His Son for us. He doesn't want anyone to perish in eternal Hell. He wants the best for us, no matter what we've done. We have no sin so big that God can't forgive us.

The splatters of red in this picture are there to remind me that Christ paid a very heavy cost for my sin, my shortcomings, and my wickedness. He shed His blood to save me from an eternity with the devil. He was fighting for my life and for YOUR life too. No one is beyond saving. God's grace is far reaching, and there is no fall too great for us to be saved. Christ proved that once and for all on the cross.

If you feel that you're so bad you can't be saved, I urge you to put God to the test. Ask Him to forgive you and see what He does in your life. "For all have sinned and fall short of the Glory of God." Romans 3:23 (NIV). God saw our sin before we were even born, and He chose to send His son to die for us so that we might be saved. I don't know about you, but to have someone die for someone like me is enough for me to want to spend eternity with Him.

Pray this with me, and then seek out a God-fearing, Bible-believing, soul-saving congregation to worship with and be baptized into Christ Jesus.

Father, I have messed up again and again, yet You loved me so much that You promised to save me if I call upon your name. Here I am asking You for Your grace and Your mercy to save me today. I have _____, yet You chose to send Jesus to save me. Lead me to a congregation that will nurture me and help show me the way.

In Jesus' Holy name!

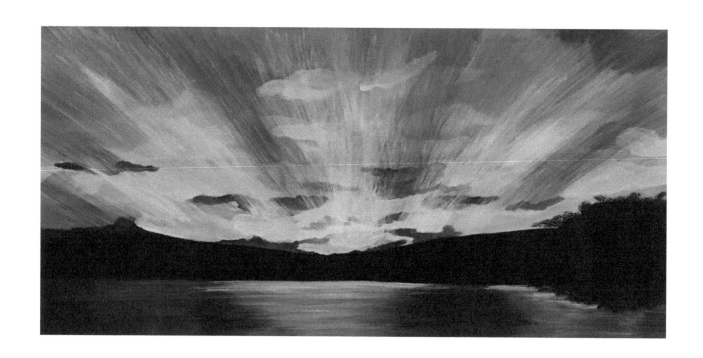

Today's Verse:

In peace I will lie down and sleep, for you alone, Lord, make me dwell in safety.

PSALM 4:8 (NIV)

𝒫eace – what does that look like to you? How does peace make you feel? Where do you find peace? How do you pursue peace?

In this painting, I feel peace in my soul. It's quiet! The water is hushed and still. The mountains are silent, and the sky is aglow with the sun setting and the rays of light are beaming in every direction. This is a picture of peace for me.

In 2017 my husband and I moved to a new home. We had only been in our home for two weeks when our picture of peace was put to the test. Our home was broken into, and many of our personal items and precious things were stolen. Some possessions would never be returned. It was the first time our home had ever been burglarized. As I walked through our home, seeing everything I had put into place now ransacked by strangers, I remember the feeling of being so violated. I wondered if we would ever feel safe in our new home. As the police came and we started naming all the things we noticed at glances that were missing, I longed for peace. I wanted answers to why this happened. However, I knew the things that were stolen were just things. God had protected my husband and I from being at home when this happened. God protected us from being physically harmed by the intruders. When we went to bed that night, we were able to lie down and sleep because we knew that God alone would keep us safe and give us peace while we slept. Have you ever had a time in your life, or maybe even now, when you didn't have peace? Do you know without a shadow of a doubt that God will give you peace and safety? If you don't, would you pray this simple prayer with me?

Abba, Father, today I just don't have peace in my life, and I long for it. This (name specifically) _____ is going on in my life and I need to see Your hand in this. I need Your peace. In Jesus' name, would you please show me what is really important, and give me peace?

Today's Verse:

And the peace of God, which transcends all understanding, will guard your hearts and your minds in Christ Jesus.

PHILIPPIANS 4:7 (NIV)

As I mentioned in my previous devotion, our home was burglarized which was like a huge storm in our lives. My husband was leaving for work around 3:30 a.m. every morning and I suddenly felt the need to have a guard dog. I didn't want a little dog that just yapped all the time. I wanted a dog that had a fierce bark and could do some damage if anyone tried to enter our home without being invited. My husband and I went to the local Humane Society and adopted a beautiful chocolate Lab mix. She was already house trained and could do some tricks on command. I've never been a dog owner before, so I didn't know how strong our new pet could be.

After bringing her home, my husband went to buy a kennel because we didn't know what size kennel to buy until we brought home the pet. He was gone forever! While he was gone, the dog (Snickers) acted like she had to go out to do some business. So I put her leash on her and double-wrapped it around my wrist. When I opened the door, she bolted and she pulled me so hard that I slammed my face down on the ground, completely missing the porch and two steps. I couldn't get my hand out of the leash and she dragged me all over the yard. When I finally got my hand out of the leash I sat up slowly. I could tell I hadn't broken any bones, but I knew something wasn't right. I had abdominal pain most of the night from the fall. The next day I had to go to the hospital emergency room. The doctor came in after viewing my CT scan and she put her face very close to mine, and she said, "You have a perforated bowel. You need emergency surgery, and you might not make it." Then she left the room to speak with my husband. When she said that to me, I suddenly knew what "the peace of God, which transcends all understanding," meant. I knew if I died, I would be with Jesus. And if I didn't die, I knew He wasn't finished with me yet. I was at perfect peace. I ended up having 5 surgeries that year on my abdomen, and I'm still here. Many ask if I still have the dog. Yes I do and I love her. She is my protector!

God, I want to pray for all those who may not know Your perfect peace. I pray that You would show Yourself to the one reading this devotion and let them know perfect peace only comes from You. In Jesus' name!

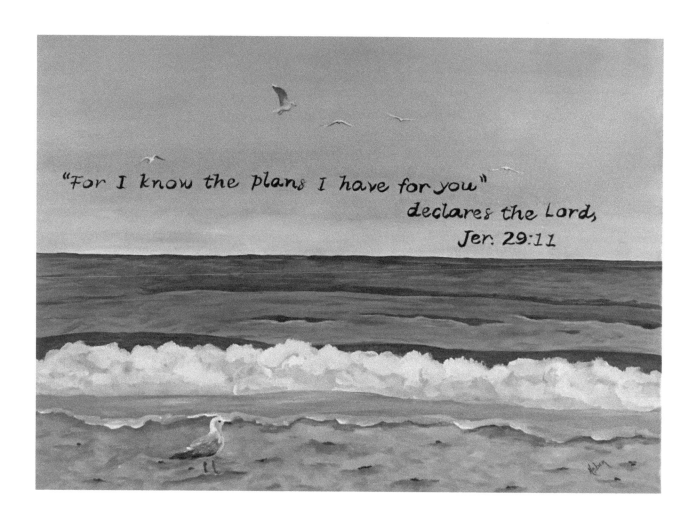

Today's Verse:

For I know the plans I have for you," declares the Lord, "plans to prosper
you and not to harm you, plans to give you hope and a future."

JEREMIAH 29:11 (NIV)

oday you may be wondering what you are supposed to do in life. You may wonder if you should go on to college after high school, or find a job with a trade instead of going to college. You may be trying to get a promotion at work and it seems like others are always ahead of you. You may wonder if you should go to work after having your first child or be a stay-at-home mom. You may be wondering if you should get married or stay single. We have so many decisions to make in our lives and sometimes we just can't see clearly what we are supposed to do. Our minds get clouded by people and things around us.

If you find yourself in this situation, I urge you to pray, pray, pray about your circumstances. Truly seek God's will in your life. Satan is a liar and he wants to make you think you're not worthy of asking God to help you discover what His will is for your life. He wants you to feel like you don't deserve God's blessings. However, this lie couldn't be further from the truth.

"And we know that in all things God works for the good for those who love him, who have been called according to His purpose." Romans 8:28. This is TRUTH! And today's scripture above proclaims that God has plans to prosper you and not to harm you, plans to give you a hope and a future. You are HIS child and He wants what is best for you.....ALWAYS! However, we have to seek His will and ask Him to guide us into all truth. He will open doors for you and you will be able to walk through them with confidence because of His promises for your life.

Abba, Father, today I'm so confused. I don't know if I'm supposed to do _____, or if I'm to do something else. Would you please remove any scales from my eyes so I can see clearly what Your will is for my life? I seek to honor You in all that I do. In Jesus' name!

Today's Verse:

Be sober-minded; be watchful. Your adversary the devil prowls around like a roaring lion, seeking someone to devour.

I Peter 5:8 (ESV)

*I*n this day and age, we have so many things that take our minds and our thoughts off of Christ. We have so many types of social media; Facebook, Twitter, Youtube, TikTok, television, radio, and so many other types of media that I'm not even aware of.

The Bible warns us about this. While all these types of media can be good; there is equally a lot of bad that comes from them. It's so easy to get tangled up in something that will take your mind off of God and what is good.

The scripture for today warns against this. It says to be sober-minded; be watchful. The lion (in this case, the devil) is seeking someone to devour. If you find yourself engaging in a conversation on one of these media sources that begins leading you down a path that does not honor God, hit delete! Leave it alone! Run from it! This should be a red flag that the conversation is not from God.

If you find yourself on a website that leads to another website (as we all have at one time or another) which is not God honoring, leave that website and don't ever go there again. It may cause you to have thoughts or feelings that are of Satan. You can't afford to be on that website.

This is exactly how Satan works. He doesn't start out by planting big seeds of evil because he knows you wouldn't follow him. But if he can creep in ever so slowly, and entice you with just a little of something that gets your attention, then he can try bigger things the next time. Be sober-minded because the devil is prowling around like a lion seeking someone to devour, and it might just be you.

If you know what I'm talking about, and you may be entangled in a situation, conversation, or website that is not God-honoring, would you pray this prayer with me?

Father, I confess I have been engaging in _____ (be specific) and I know this does not honor You. Please take this temptation away from me and help me to seek to honor you with my life, my words, and my actions. I want to do what is God-honoring. When people see me, I want them to see You in me. Give me the strength to say no to these temptations. In Jesus' name!

Today's Verse:

As he thinks in his heart, so is he.

PROVERBS 23:7 (NKJV)

The day I was asked to paint this picture, it reminded me of thoughts in my mind. Thoughts that had seemed so out of proportion, and some thoughts that are not in compliance with how God sees me. It reminded me of how sometimes, I've believed lies about myself that were not true. In my life, I had believed the lie that I wasn't good enough to be a follower of Christ. In high school and throughout much of my adult life, I struggled with the thoughts of my appearance. I had gained a lot of weight before and after childbirth, and I just couldn't seem to shake that weight. But that weight was not only weighing down my body, it was weighing down my mind, making me think no one would want to be around me. Most of all, why would Christ want me to follow Him and try to lead others to Christ? Wouldn't He be afraid that people would make fun of me and not want to follow Him?

But one day, I came across this scripture in Proverbs, as well as the scripture in 2 Corinthians 10:5, which says, "We demolish arguments and every pretension that sets itself up against the knowledge of God, and we take captive every thought to make it obedient to Christ." When I read these two verses, I knew I had to stop allowing Satan the stronghold that he had had on my life, for most of my life, and start being obedient to Christ no matter what my appearance was. I had to take captive those thoughts that caused me to feel so insecure. I needed to share Jesus, and His love for me. He has that same love for you. If you've never struggled with weight issues, good for you! But maybe you have struggled with another addiction, be it drugs, alcohol, porn, eating disorders, gambling, bullying, gossiping, or some other addiction. Whatever you struggle with, I'm here to tell you that there is a God who will help you take those thoughts captive and bring them into obedience so when you see yourself, you see what God sees. He can take our failures and turn them into testimonies. If you're someone struggling, would you please stop and pray with me now?

Father in Heaven, I admit my addiction to_____, and I ask for Your strength in my life to overcome this addiction and thoughts that I'm not good enough. Your cross says I am good enough, and that's enough for me. Help me see myself as You see me. In Jesus' name!

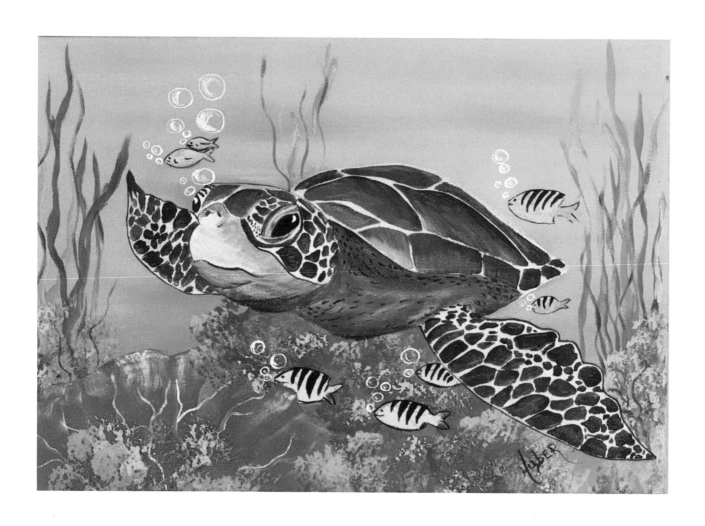

Today's Verse:

All kinds of animals, birds, reptiles and sea creatures are being tamed and have been tamed by mankind, but no human being can tame the tongue. It is a restless evil, full of deadly poison.

JAMES 3:7-8 (NIV)

I love sea turtles. They are such graceful swimmers in the ocean. But did you know that they do not retract their flippers and head into their shells like land turtles? Their rear flipper is used as a rudder for steering them where they want to go. The rear flipper is very small in relation to the rest of its body.

The same is true of the tongue in human beings. It is a very small part of our bodies, yet, it can cause a lot of trouble by speaking a word that is unkind. Our words can cause damage to someone for the rest of their lives. We say things and soon forget what we've spoken, but if those words are spoken to someone when their heart is already low, it can remain in their hearts and minds forever. Has anyone ever said an unkind word to you? How long have you carried those words around with you? Maybe someone told you that you would never amount to anything in life, and you believed them. Maybe someone said you were too fat, or too old, or too whatever, and you believed those lies. My friend, those lies are from Satan. I want you to know you don't have to accept those lies. Maybe you've already started down that path of self-destruction because of what someone said about you a long time ago. But you don't have to accept those lies any longer. Satan has no hold on you anymore. Let's give this to God today and rebuke Satan in the name of Jesus.

Lord God, I'm crying out to you today. In my past, people have said things, awful things _____ (name the things) about me, and I ask you to first forgive them for what they have said. They don't know the damage they have caused in my life. But I'm rebuking those words in the Name of Jesus, and I ask You to help me rise up above those words, as You rose from the grave. People said many horrible things against You, and yet You forgave them and rose from the grave so that we might spend eternity with You. You loved us that much! No one is like You, but I want to strive to become Christ-like in all that I do. In Jesus' name!

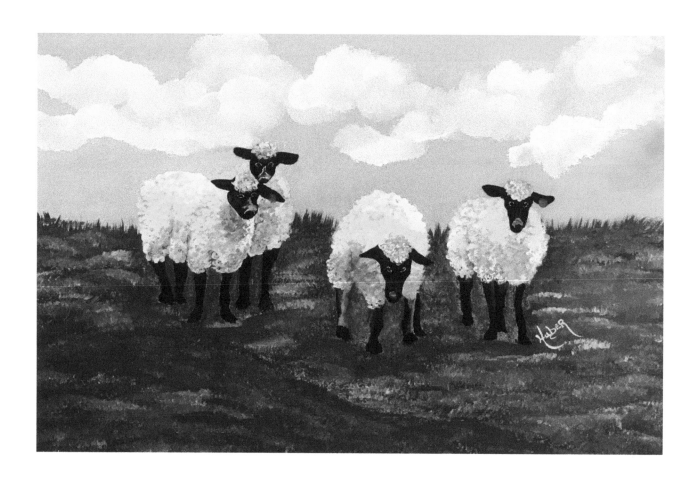

Today's Verse:

And the Pharisees and scribes were complaining, "This man welcomes sinners and eats with them!" So He told them this parable, "What man among you, who has 100 sheep and loses one of them, does not leave the 99 in the open field and go after the lost one until he finds it? When he has found it, he joyfully puts it on his shoulders, and coming home, he calls his friends and neighbors together, saying to them, 'Rejoice with me, because I have found my lost sheep!' I tell you, in the same way, there will be more joy in heaven over one sinner who repents than over 99 righteous people who don't need repentance.

Luke 15:2-7 (NIV)

*W*hat Christ is saying here is, that YOU are important to HIM. He wants you in His kingdom. He wants you around for all eternity, rejoicing and praising Him. He would leave behind 99 other righteous people to find one person who has gone astray.

Is there something or someone in your life that is causing you to go off track from the plans God has for your life? If so, spend some time meditating on the scripture above and allow that to sink in. God. Cares. For. You! God loved us enough that He was willing to take my sins and your sins upon Him and die on a cross for us. He knew us before we were born, and He knew we were going to mess up. He knew we would be in great need of a Savior, and He was willing to die for you and for me. Do you know anyone else in this life that would do that for you? Didn't think so. I don't know of anyone that would do that for me either. But Christ did!

God, I admit that I have gotten off track. I've done _____(be specific) and I ask for Your forgiveness. Would you please support me and give me the strength I need to say no when I need to. I want to be the sheep that You rescued to be with You for all eternity. I want to follow You, and share my story with others so they may be rescued. I want my friends and family to be with You for all eternity too. I don't know of anyone else on earth that would do that for me, and I thank You. In Jesus' name!

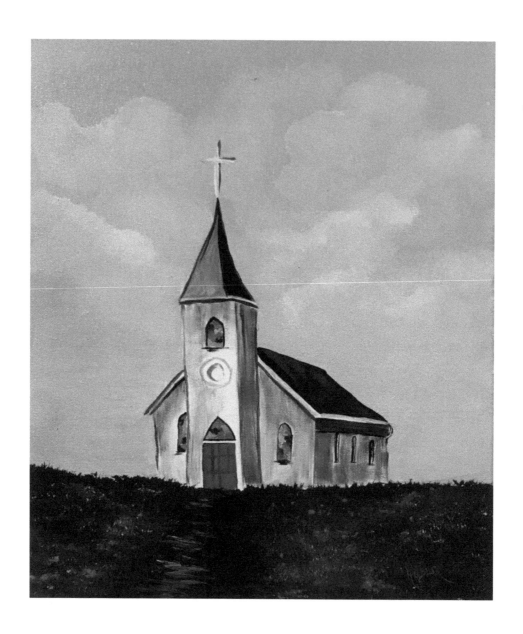

Today's Verse:

Some people have gotten out of the habit of meeting for worship, but we must not do that. We should keep on encouraging each other, especially since you know that the day of the Lord's coming is getting closer.

HEBREWS 10:25 (CEV)

I love this painting of the old church. It reminds me of the church I attended when I was younger, and the church where my husband and I took our wedding vows.

When I was a child, I thought everyone went to church. I always thought church was a place to go every Sunday for worship. I wasn't very old when I learned that not everyone goes to church, nor thought it was important.

It wasn't until I was much older that I learned that church was not a building, and that worship didn't have to be confined to bricks and mortar. I love worshipping God in the woods, or when we're on our boat. I love to worship while I'm painting. I listen to praise music and sing along; all the while I'm worshiping God.

However, this scripture is very clear about the fact that we should go to a place of corporate worship, whether it's a group of people in your home, or in a building. It's there that we receive encouragement from one another to walk the walk that we are called to walk. There have been times in my life I just don't think I could have made it through situations if it had not been for the love and relationships of our church people/church family. I have said many times that I just don't understand how people can do without the Lord and others to help them through this crazy life!

Life can deal us some pretty harsh things, whether we're Christians or not. Things like cancer, divorce, child abduction, addictions, unfaithfulness, rage, murder, suicide, slander, and so much more, are no respecter of persons. It doesn't matter if you are the President of the United States, or a factory worker. Any of these "things" can attack any of us. But how we deal with these "things," is the difference.

"Lying lips are an abomination to the Lord, but those who deal faithfully are His delight."

PROVERBS 12:22.

Abba, Father, today I'm hurting. I've had this "thing," _____ (be specific) that has happened, and I'm not quite sure how I'm going to make it through. I need Your wisdom to deal faithfully with this. My human instinct is to lash out in anger, or try to get even. But I know that's not how You would have me deal with this. Would You please speak to my soul in only the way You can, and reveal to me the best way to handle this situation? I want Your will in my life. In Jesus' name!

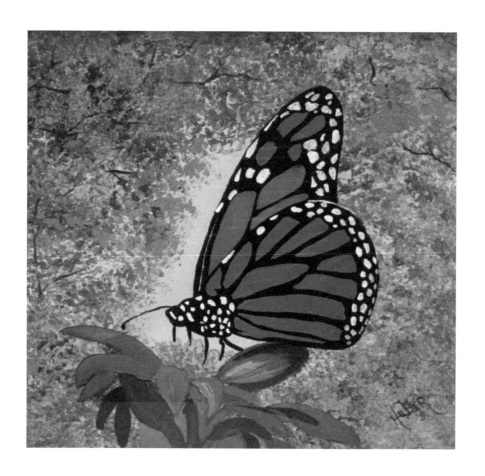

Today's Verse:

Therefore if any person is (engrafted) in Christ (The Messiah) he is a new creation (a new creature altogether): the old (previous moral and spiritual condition) has passed away. Behold, the fresh and new has come.

I Corinthians 5:17 (AMPC)

*D*id you know that there are four stages of the life cycle of a butterfly? There are also stages to becoming a Christian. See how similar we are to the butterfly in this devotion.

Stage 1 for the butterfly is the egg stage. The butterfly begins life as a fertilized egg. For so it is with becoming a Christian. We begin by hearing the Word and letting it sink deep into our hearts and minds, sort of like the fertilization period of a Christian.

Stage 2 of the butterfly is the Caterpillar or Larva stage. The main activity is eating and feeding itself. They almost never stop and they grow quickly. As a Christian, you begin reading the Bible, the eating and feeding stage. When we first start out, we just can't seem to get enough of the Word. Before we go into the third stage of Christianity, we grow in the knowledge and wisdom of Christ. We are much stronger than when we heard the Word for the first time. We begin to outgrow our old habits because we know from reading the Word what we must do to be a healthy Christian.

Stage 3 in the butterfly's life is the Pupa or Chrysalis stage. During this stage, the old body parts of the caterpillar go through an unbelievable alteration called Metamorphosis. In this stage, the wings begin to be seen. When we become a Christian, our minds begin to change to think more like Christ. We want to be transformed. We begin to sprout wings (not literally), and we begin to grow in Christ's image.

Stage 4 for the butterfly is the adult stage in their lifecycle. When a butterfly develops its wings are wet and wrinkled. It takes them a while to become strong enough to live that adult life and start the cycle all over again. That's the way it is as a new Christian. It takes a little while to build up the momentum to fly on our own and be able to share our testimony/story with others. However, once we feel strong enough and brave enough – watch out! We are now someone who will go to great lengths to help others get to know Christ as we have.

Father, I pray for the person reading this devotion. May they hear and understand how important it is to share their story with other non-believers in Christ. By doing this, may they become stronger and braver each time they share what You mean to them. May they be a light in a broken world that desperately needs You. In Jesus' name!

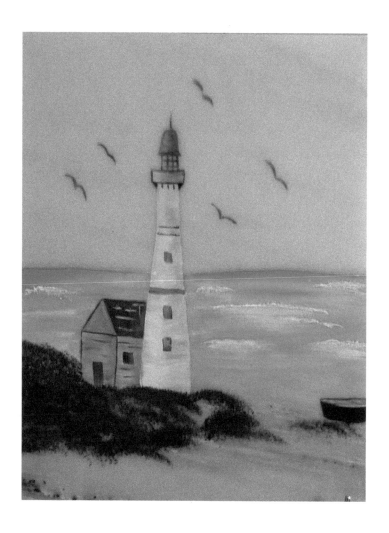

Today's Verse:

Neither do people light a lamp and put it under a bowl. Instead they put it on its stand, and it gives light to everyone in the house. In the same way, let your light shine before others, that they may see your good deeds and glorify your Father in heaven.

MATTHEW 5:15-16 (NIV)

odern lighthouses came into existence in the 18th century. Before modern lighthouses, fires were lit on hills so that mariners were guided by its light through the darkness. These fires were lit to guide ships to safe passageways as they traveled on the sea. Just as lighthouses guided mariners, and still do to this day, so the Light of the world, Jesus Christ, lights our way as we walk with Him.

Light in the Bible often refers to Jesus Christ, or paths of righteousness. In Matthew 5:16, it says, "In the same way, let your light shine before others, that they may see your good deeds and glorify your Father in heaven." In John 12:46, it says, "I have come as Light into the world, so that everyone who believes in Me will not remain in darkness." (NIV) If we follow Jesus Christ, we walk in the Light. We no longer have to remain in the darkness.

Darkness in the bible refers to evil, sin, or wrong doing. How many crimes happen in the night? It's because people don't want to be seen. It lessens their chances of being recognized or caught red-handed in the offense they are committing.

In Job 12:22, the scripture speaks of darkness this way, "He reveals mysteries from the darkness and brings the deep darkness into light." But the Bible is very clear that the sins of man will become visible. Ephesians 5:13 puts it this way, "But all things become visible when they are exposed by the light, for everything that becomes visible is light." (NIV)

You see, we may think we can get away with things by doing them in the darkness, but there will be a time that what is done will be visible for all to see. The truth is, God sees all, and He knows all that is done. We may not see justice being brought to light on this side of glory, but there will be a time of reckoning with the Lord. People may think they got away with their sin, but the passage in Ephesians says that "all things become visible when they are exposed by the light, for everything that becomes visible is light."

Abba, Father, for the one reading this today that may have unconfessed sin, please allow Your words to sink deep into their hearts. Help them to repent. It is not Your will that anyone should spend eternity in hell. We were created to give You glory and honor and praise. Please forgive me if I have unconfessed sin, so I may bring glory to You in all that I do. In Jesus' name!

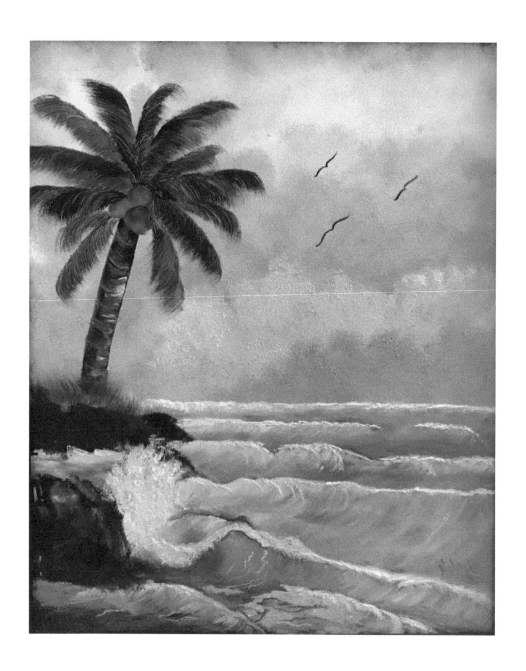

Today's Verse:

More than the sounds of many waters, Than the mighty
breakers of the sea, The Lord on high is mighty.

PSALMS 93:4 (NIV)

*W*hen I painted this picture, I imagined myself sitting on the ground under the palm tree. I love the ocean. I love watching the birds in the air and on the sand. I love the sound of the crashing of the waves on the rocks. In Psalms 93:4, it says that our Lord is greater than all these sounds of the many waters.

We tend to forget that God is so great! We overlook the fact that God created EVERYTHING! There is nothing on earth that He doesn't know about. He sees the birds in the sky, and yet He cares for them. He sees the waves of the sea, and yet He created the sand as a boundary for the strong waters. His love for us is so much more than we can possibly comprehend. We even doubt His goodness for us, and we question God when things don't go our way.

Have you ever prayed for something, and God actually answered your prayers exactly the way you desired? Then maybe you caught yourself saying something silly like, "Wow! That really happened!" Or you caught yourself questioning whether God answered your prayer or if it was a coincidence?

James 1:6 (NIV) says, "But when you ask, you must believe and not doubt, because the one who doubts is like a wave of the sea blown and tossed by the wind."

When we doubt our prayers can be answered, this scripture tells us we are "like a wave of the sea blown and tossed by the wind." I don't know about you, but I know I've doubted plenty of times that my prayer was too big for God. And then I hear God laugh and say, "Is there anything that is too big for me?"

Sometimes, we ask for things that are not of God, and He will say no. Sometimes, He will ask us to wait, and then there are those times when everything is lined up and what we pray for happens almost immediately. When we pray, we shouldn't doubt in our hearts. Even when we can't see, He's still working out the details of our lives.

God forgive our unbelief that You will answer our prayers. You may not always answer them the way we want You to, but You will give us what we need when we need it. I'm so thankful You are God and we are not. We would make such a mess of things. Help us believe that You will choose the best way to answer our prayers. Thanks for answered prayers. In Jesus name!

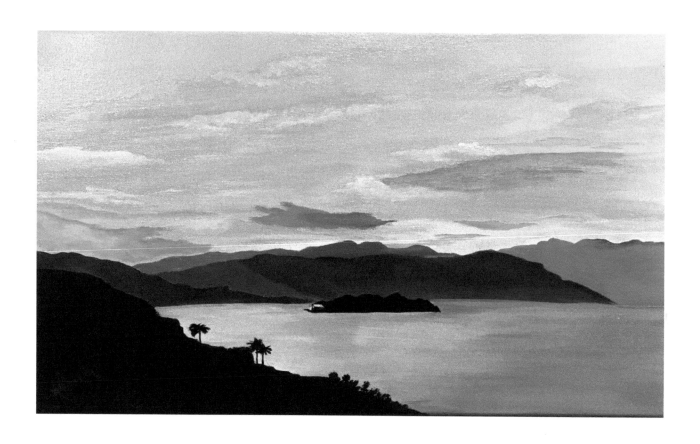

Today's Verse:

The Faithful love of the Lord never ends! His mercies never cease. Great is his faithfulness; his mercies begin afresh each morning. I say to myself, "The Lord is my inheritance; therefore, I will hope in him!" The Lord is good to those who depend on him, to those who search for him."

LAMENTATIONS 3:22-25 (NLT)

*I*n this painting, the waters in Italy are so beautiful! The vibrant hews of the sky are some of my favorite colors. It looks so peaceful, and it reminds me that God's love and mercies for me never end. His faithfulness for me is new every morning. Why would I not put my trust and hope in Him?

We are all given gifts from God. Some of us can paint beautiful pictures, and we try our best to replicate what God gives us to behold. Some are given talents to work in the church helping God's people. Some are given the talent of singing expressive songs that touch the soul. Some are given talents to interpret scriptures so others can understand more clearly. Some are given the gift of compassion; others are given gifts of being able to give whatever, whenever and wherever is needed. In all these gifts, where would we be if God's faithful love for us ended? Where would we be if we weren't given another day to do His will?

Do you pray for opportunities to use God's gifts? Do you look for ways to be compassionate to others? When you're with your children or grandchildren, do you look for ways to teach them about God's mercy? There are so many ways to use the gifts God has given you. Will you pray with me to use your gifts for whatever, whenever and wherever they are needed?

Heavenly Father, today I come to You and ask that You help me keep my ears and eyes open to hear and see where You would have me use my talents. May I learn to depend upon You so that You can use me. Help me show mercy and compassion to Your loved ones today so they may see You in me. May I emulate Christ in all that I do and say. When you present these open doors to me, help me to walk through them and depend on You so that I may bring glory to You. In Jesus' name!

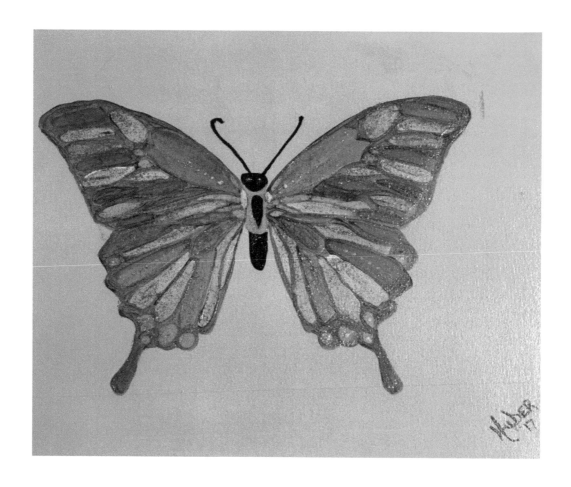

Today's Verse:

Then if my people who are called by my name will humble themselves and pray and seek my face and turn from their wicked ways, I will hear from heaven and will forgive their sins and restore their land.

2 Chronicles 7:14 (NLT)

Recently, I was scrolling down my Facebook Newsfeed, and I ran across this quote: I can turn coal into diamonds, sand into pearls, and a worm into a butterfly. I can turn your life around too. —God

We all know that a butterfly goes through cycles to become the beautiful creature that God intended it to be. Likewise, in our walk with Christ, He accepts us as we are, where we are, but He loves us enough not to want to leave us there in that state. He wants to turn our lives into something so much better and stronger than we could ever imagine.

Do you remember where you were when you first realized that you needed God? I do. My heart was broken, and my life was in pieces. But that night, I gave my life to Christ in a way that I had never done before. Becoming the Christian God wants you to be is a journey or a cycle, if you will. No one else can walk your journey for you. I was baptized at the age of eleven because I knew I wanted the Lord in my heart, and I repented and was made complete with Jesus. But as I grew older, life began to unfold, and sometimes life isn't so kind. It breaks you; it scars you; it hurts the deepest parts of your heart. But it's through this cycle that God begins to reveal Himself to us. As we learn to repent and seek God's will for our lives, God can restore us to what He intends us to become.

We would be on overload if Christ gave us all His promises at once! It may resemble the person who inherits a million dollars, and doesn't know where to spend it first. No! He gives us what we need when we need it. Giving my life to Christ was just the beginning of my journey, and it can be the beginning of your journey too.

Giving your life to Christ is where He can begin to turn you into the beautiful butterfly that grows over time and learns to share God's word and your story with others. There's no magical age or time to give your life to Christ. The important thing is if you feel Him nudging at your heartstrings, then it's time. He can turn your life around, but He never said it would be easy. He just promises to do it for you.

Lord, I come to you praying for the one reading this devotion. I pray that maybe something I've said will touch their heart. Let them know they are not alone. Help them to know You alone can turn their lives around if they will repent and take You as their Lord and Savior. In Jesus name!

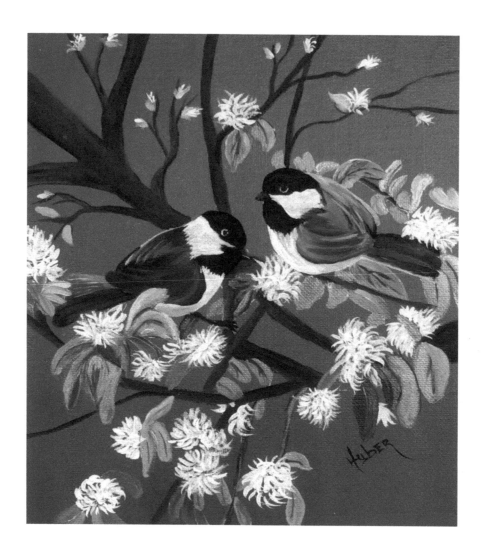

Today's Verse:

Therefore I tell you, do not worry about your life, what you will eat or drink; or about your body, what you will wear. Is not life more than food, and the body more than clothes? Look at the birds of the air. They do not sow or reap or gather into barns — and yet your heavenly Father feeds them. Are you not much more valuable than they? Who of you by worrying can add a single hour to his life?...

MATTHEW 6:25-26 (NIV)

*W*orry – probably one of the greatest sins of a Christian. We worry about what we will eat, where we will eat, what we will wear. We worry about our kids; we worry about finances; we worry about our health and the health of our loved ones. We worry about our loved ones being saved. We. Worry!

In this scripture, Christ explains how he takes care of the birds of the air, and that we are much more valuable than they. We can't add a single hour to our life by worrying. Yet we still do it.

Have you ever thrown out bread crumbs to feed the birds? I have, and that's God using me as His vessel to feed the birds.

I worry about my children and my grandchildren, my daughters-in-law, and the lost souls of this world being saved. Yet I cannot give them the relationship I have with Christ. All I can do is pray for them. I have to be His willing vessel should He decide to use me.

So many times, we want to do God's job, but we can't. No matter how we try, we just can't. Only He can change a heart to be like His. Only He can turn the lost into saved. Only He can make a blind person see. Only He can turn the life of addiction into a life of freedom. Only He loved each of us enough to die for our sins. I don't know of any other human being that loved me enough to die for me, or to save me from myself. The great thing is, Christ promises to do just that because He says we are more valuable than the birds of the air, or the lilies of the field. We are that important to Him. He loves us that much!

If worry is something in your life, would you please give whatever you're worried about to Him and trust that He will see the situation or the person through the circumstance.

Father, today I confess that I worry about _____(be specific). I ask you to forgive me of my worry, and help me to know that You are in the midst of this crisis. Help me to know that You see what is best for _____. Forgive me when I fail to trust You for the good in this situation. Lord, I ask that You take this worry from my heart and replace it with Your perfect peace and joy. Use me when You need to, and give me the wisdom to stay out of Your way when You are trying to work out Your will in this situation. Give me peace and trust that You know what's best for _____. Give my loved one a heart that is ready to receive Your help, Your love, Your forgiveness, Your promise of eternal salvation. In Jesus' name!

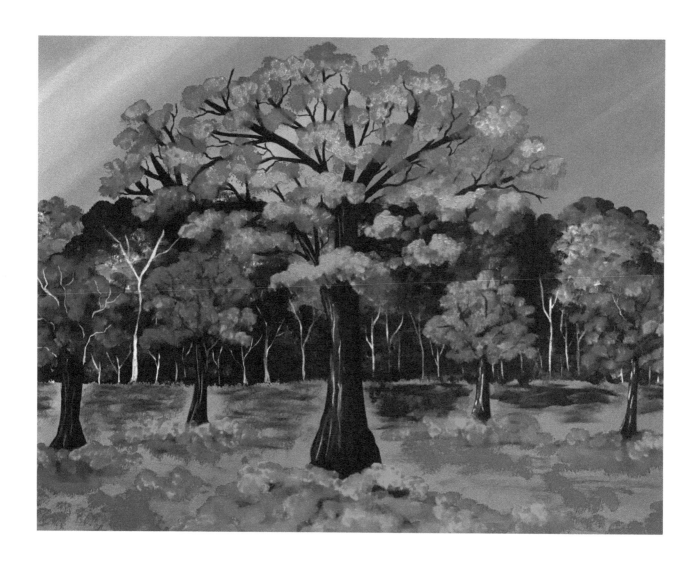

Today's Verse:

Yes, I am the vine; you are the branches. Those who remain in me, and I in them, will produce much fruit. For apart from me you can do nothing.

JOHN 15:5 (NLT)

*O*ut of all the pictures I'm been commissioned to paint, this was among the most popular. As I look at this painting, I remember Jesus telling us in this scripture that He is the vine and we are the branches. Look at the trees. Every tree has a solid tree trunk. The trunk in the tree demonstrates how strong and caring Jesus is for us. The trunk is stout enough to support all those branches, which represent us. We are held up by the love and strength of Jesus Christ. Without this trunk, we cannot survive on our own. But when we are connected to the trunk, or in this case, Jesus Christ, there is nothing that is impossible to us. A tree is considered very frail with only one limb, and we would be very weak without Jesus Christ in our lives.

When a tree has many branches, it is strong enough to weather the storms that may come. A tree is not meant to live with only one limb, and we are not meant to live the Christian life without other Christians to cheer us on, to share with, and to bond with. We are grafted into the vine of Jesus Christ. A tree produces so much more fruit when it has many branches, and when we have many Christian friends, we can find our walk with Christ so much more productive. We don't have to be the only branch on the tree. We weren't meant to carry the load all on our own. We can produce much more fruit for the Kingdom if we will do it with the help of Christ and other Christian friends.

Lord, strengthen me today to be a strong branch, and help me to be willing to allow other Christians to help me carry my load. Help me to realize I'm not alone in my Christian walk, and that You are the center of our lives. I need You more in my life so that others see less of me. In Jesus' name!

Today's Verse:

And why do you worry about clothes? See how the lilies of the field grow. They do not labor or spin. Yet I tell you that not even Solomon in all his splendor was dressed like one of these. If that is how God clothes the grass of the field, which is here today and tomorrow is thrown into the fire, will he not much more clothe you, O you of little faith?

MATTHEW 6:28-30 (NIV)

People often put their hope in tangible things such as their clothing, jobs, wealth, homes, cars, and the list goes on. But in this passage, Christ is telling us that he takes care of even the flowers of the field. He's saying that if He's able to care for something as minute as flowers, do we not mean much more to Him than that. He's saying He will take care of our every need. We just have to trust Him for our needs to be met. What He provides might not always be what we WANT, but it will be what is needed.

I remember when we moved to Kentucky. I wanted to work at the school district so I could have the same days off as our boys. I prayed, "Lord, please have a job ready for me at the school district where our boys will be going to school. I don't know anyone in Kentucky who could take care of them after school if I got a job elsewhere." The very first Sunday we went to church, a gentleman introduced himself to me and he said he worked at the school district. I was so excited because I was sure he was going to offer me a job in the office. Now I know God has a sense of humor, but you can imagine me picking my jaw up off the sidewalk when the man said he was looking for bus drivers! I knew nothing about driving a bus. It was then that I realized how important it was to pray specifically for what I wanted and needed. What I didn't want was to drive a bus! So God and I had a little talk. Later, I honestly did get a job with Head Start, and I had the same days off with my boys.

Do you worry about things? Do you sometimes ask God for things you want, instead of what you need? If you will trust God, He will provide just what you need, and sometimes it's even what you want.

God, I must admit sometimes my prayers must seem selfish and superficial to You. Please forgive me. I don't mean for them to be that way. I only want to have what You want and need me to have. Please help me to rely on and trust You for every part of my life, for my children's lives, and for my grandchildren's lives. In Jesus' name!

About the Author:

Gail Huber is a resident of Kentucky, but was born and raised in Illinois. As a longtime art teacher, one of her greatest accomplishments has been to share her art with others through "Painting With A Purpose." She has traveled to several churches and other venues teaching art classes to help people raise money to support missions such as men's and women's shelters, soup kitchens, Avenues for Women, Frankfort Women's Shelter, two missions in Haiti, Mashindi Medical Mission in Zimbabwe, Mirembe Primary School in Uganda, and various church camps. She has also donated artwork to other missions, such as Redemption Ranch in Tennessee, various women's groups, and local churches to help them raise money for their mission projects. The main goal of her artwork is to share the talents God has given her in a way that pleases Him.